Average Joe and Jane
POEMS

Paula Glynn

Stereotypes

Average Joe and Jane

Average Joe and Jane
Getting it mostly right
Your basic 2.4 family
In modern working class Britain
With average hair care
Average looks
Average houses
Average jobs
Average children
Nothing obviously risqué
With their normal lives
Never winning the lottery
Never lavishing in mansions
Never going to film premieres
Simply living lives
As normal as the alarm
Going off at seven in the morning.

Chatty Cathy

The chatty Cathy
Always full of ideas
Full of heart and soul
Always contributing to conversations
Always with fresh ideas
Talking to people
Like a best friend
Talking to people on the bus
Talking to their classmates
Talking to their workmates
Talking to other church goers
Talking to shop staff
Just talking to everyone.

Arthur Or Martha

Gay men and women
Never fitting the stereotype
Of certain looks
And ways of talking
Even the bi sexual
Not fitting the stereotype
No longer seen as different
The homosexual seen
Without fear or judgment
Society much changed
The gay no longer in therapy
The gays having fun festivals
And happily dressing up
In flamboyant clothing
And outrageous makeup
Singing fun and deep songs
Because in this world and society
Every gay person knows they belong
Old day beliefs of homosexuality long gone.

Nice But Dim Tim

The character of Nice But Dim Tim
Does play its role in society
For the stupid
Are - well - stupid
Not being able to
Understand people a curse
Confusing honesty
With being a jerk
Not knowing the difference
Between right and wrong
Not knowing when
To say yes and say no
Stupidity the nature
Of Nice But Dim Tim.

Sally The Square

Sally is the class square
She does all her homework
And drops it onto her teacher's desk
First thing every morning

With a computer printout
With perfect grammar
With perfect standards
Sally the Square
A girl genius with a computer
Always learning in the classroom
And Sally shall graduate soon
An expert at mathematics
An expert at science
An expert at English
An expert at everything
And Sally The Square
Worth all the gold in the world.

Sarah the Shopaholic

Sarah loves shopping
She'll buy everything from
The women's clothing shops:
From vibrant designer dresses
To beautiful designer handbags
To intricate designer jewellery
To perfect designer high heels
Because Sarah the Shopaholic
Is a bit of a fashion victim
But she loves fashion
And loves looking stylish
Being Sarah the Shopaholic
And she also loves colourful and creative
Outfits from neon and neutral pantsuits
To designer deep blue jeans
And designer short and long skirts
And also reading Cosmopolitan magazine
Does excite fashion victims
Like Sarah the Shopaholic.

Charlotte: Church Mouse

Charlotte attends church
Every Sunday morning
Because the priest's sermon
Does hold much truth
In modern life and society
Listening to sermons
About life, loss and love
To even mortal sins
And redemption

Therefore saving Charlotte's soul
Charlotte with a conscience
And talking to the priest
About her wanting to hurt others
And how to redeem herself.

Bella Big Time Diva

Watch out Mariah Carey
Bella Big Time Diva
Is alive and kicking
Wearing her blue sequinned dress
Her Louboutin high heels
Her show stopping fuchsia lipstick
That only Bella Big Time Diva
Can pull off and get away with
Plus enjoying the nightlife
Enjoying the never ending neon signs
Enjoying the vast variety
Of people and personalities
From white to black
And young to old
A place innocence happily lost
A place happy memories are made
And all fears do vanish with every fun show
Time seemingly going slow
For Bella Big Time Diva
Wears that fabulous fashion
Her booty she does parade
Looking like a supermodel
Looking like a true star
The nightlife ongoing
Bella Big Time Diva
Loving supermodels and rock stars
Always sashaying down the catwalks
Always playing on stage
With their exciting and melodic guitars.

The Wheel Of Reincarnation

At first there's only dark,
Twisting atoms surrounding bone,
Eyes formed and developed,
Lungs and heart,
No impact on conscience,
For lungs could burst,

And heart could bleed,
But the soul does not yet know,
Their body to trap them,
In a prison created by evil,
Evil within their soul,
For they will grow,
To have the killer instinct,
The first time in the womb,
The only time no conscience,
A woman to cry out,
Her son born,
Satan's mother,
To teach her little boy,
How to handle life,
But he gets it twisted,
No knowledge of pain,
Until the end of his life,
When he meets his maker,
The man in the wall,
No angel to come to call.

The second time in the womb,
His soul to not twist with rage,
Knowledge of hell,
Knowing the pain of the kill,
But foolishness enters here,
His life filled with fear,
With no awareness of why,
And he wants to die,
To escape his pain,
To end the torture,
His crimes from his previous life,
Unknown and trapped,
In the prison of time,
And people surround him,
Telling him he's got it wrong,
His soul to have burnt in hell,
A place where spiders dwell,
Hiding in the shadows,
Hiding in the cracks of his mind,
Demons to be cruel,
Life not having been kind,
But when he dies,
He will celebrate with a party,
And be strong,
For learning his lesson well,
Has meant the end of hell,
His soul to never kill again.

The third time in the womb,

And now he is not a fool,
His strength and courage,
Making him ultra cool,
For now he is the hero,
People praising and worshiping him,
As he stands in front of the crowd,
Sharing his thoughts and creativity aloud,
And the world loves his work,
For he has already grown wise,
And has learnt,
His morality and compassion,
Bursting in his heart,
Knowing love and power,
Are closely mixed,
And problems are always fixed.
The son a happy man,
Who travels the world,
Seeing magnificent sights,
Every adult and child,
Seen in glorious technicolour,
Souls from deep in time.

In every time in the womb,
Lessons are going to be learnt,
Every soul - whether male or female -
To grow and learn on God's jewel,
Earth carrying its people,
For the wheel of reincarnation,
Cannot be stopped,
And hell ends for everybody,
All souls to celebrate in the end,
To have everybody their friend,
All souls to grow and learn,
Where poverty is defeated,
For every life is precious,
People heart-to-heart,
And the soul grows stronger with love,
And the lord watches over all from above,
Everyone having been a demon once,
But now angelic and grinning with the sun,
For everybody is worthwhile,
And even those poor in money have won.

I Don't Want To Write This Horror Story Anymore

I am sick and tired of hell
I am fed up of learning my lesson well
I want no more evil or soul consuming fear

I don't want anything evil coming near
I don't want to be tortured
And I don't want to feel torturous fear

Whether in daytime or night-time
Whether in technicolour real life
Or in regular clock sleep time
Fear is pointless
Rage is pointless
Nightmares are unnecessary

At least with this happy soul
That does like to rock and roll
Loving life like masterful music
Plays at public popular concerts
On creative CDs and DVD's
Every genius recording artist

Living the envied dream
Not needing to write horror stories
About situations scary or obscene
Or in a killer's psychotic dream
Only those brutal killers
With never ending nightmares

I now write my happy story
That comes around every birthday
I write about fantastic people
Vibrant colours and languages
And places that make up this planet
And this amazing human race
Where love takes hates place.

The Hierarchy Of Angels

The angel to be a benevolent celestial being
Acting as intermediaries between God and humanity
Roles of the angels
To protect and guide human beings
Carrying out the tasks of God,

The Abrahamic religions
Seeing angels in hierarchies
Their names Michael and Gabriel
Titles such as seraph and archangel
And theological study of angels
Known as angelology
A popular study of celestial beings,

Angels falling from heaven
To be unwise fallen angels
Where mistakes they did make
But God will revive their soul
And back to heaven
Their angelic souls for God to take
Back into the ether
Back into paradise
Where they never fall again,

Angels to have the white wings of
Birds, stretching far across
The blue of the sky
Feathers to not fall
But sometimes left in a scattering
To send a message of hope
And a sign they're there
They to wear their halos too
With much pride,

And the grace of God
Who sends his angels
To share his love
Send these celestial beings
Down from above
And for God to send his doves
To signify God's love
A message of peace and unity,

The word angel to come from
Old English 'engel'
And the Old French
'angele', derived from
Late Latin 'angelus'
To translate into
The word 'messenger'

For angels are always known
Angels are always there
And always share
Their love and joy
Sending hope to humanity
For God did create the world
And God created every
Man and boy,
Woman and girl,

Angels sent to help
Those in need

To stop people hurting
And for no one to bleed
For angels help everyone in need
Their angel wings
Their halo
To shine from that blue, blue sky
And tell of unity,

Tell of friends and family
Their destiny heaven
Where no hell waits
For this is God's world
Where there is no hate
Where everyone relates
When it comes to love
And souls go to paradise
God to save all souls that he takes,

And heaven is a place on earth
Where no devil waits.

Angel Feathers

Everything must go
The apartment empty of
Its furniture and possessions
The beige carpet pulled up
The kitchen cupboards bare
The windows with no blue curtains
The neighbours that did never stare

The busy bus takes me away
To a brand new place
A place where I will be home
Another home after the end
Where I said goodbye to every friend
As they wished me lots of luck
In an exciting new and vibrant town

I started office work on Monday
I have a day of rest on Sunday
And Friday night it's on the town
Where I meet various friends
And play the innocent clown
There my eyes clap onto him:
The man of my dreams

I wander up to him and say hello

The man with a worthwhile ego
I notice his dark brown eyes
His allure and charisma
A beautiful surprise
And a surprise he's single
But not anymore:

I am his dream woman
His magical future wife
Now I enter his loveless life
And enjoy love and passion
A never-ending love between us
The man my hero and confidant
A man with a face like a work of art

Now innocent children follow
The children of tomorrow
Raised with love and praise
Respect and never neglect
Children with angel feathers
And love from heaven above
Love that shall last forever.

Ticketmaster

'Free tickets to hell! '
'Free tickets to hell! '
He shouts in quick succession

A man with a black top hat
And freshly polished loafers
And an odd face never to be forgotten

A circus of adults and children
Milling about some strange place
Not yet knowing smiles to be erased

With all the amazing sights
You can see and continually hear
No day or night boring here

From sights of Jurassic Park
That ancient gigantic T-Rex
To scare in those nightmares of the dark

Rides on that famous dinosaur
Children of the damned
Feeling bizarrely excited and strangely glad

Assuming nothing going to go wrong
There being nothing scary or bad
About taming the devil's dragon

Meet the legendary Pinhead here
As you face your brutal killer fears
Your time in happy heaven done here

Travel throughout the tunnels of hell
Have the devil weave his wicked spell
Your time not yet done in hell

Tunnels featured in Hellraiser: Hellbound
A film graphic and profound
Its content true to life and death

Have the devil dial your home number
You to be on the ship of fools
Sailing on the stormy sea going under

Pray as you see your blood
Knowing the evil you caused
When you stole love

'Free tickets to hell! '
'Free tickets to hell! '
Now the Ticketmaster

Knows you suffer as well
The devil teaching vital lessons
With his never-ending wicked spell

The ticketmaster doing the devil's work well
Seeing evil adults and children in hell
Their evil to never attract but instead repel

Lessons time does tell
The otherside mysterious
Learning lessons deeply serious.

The Good Samaritan And The Thief

THE GOOD SAMARITAN

The good Samaritan
Always giving and kind
With an angelic soul

That is all knowing and wise
Knowing God loves all his people

The good Samaritan
Giving love and affection
Helping the hungry feed
Helping the blind see
Helping the deaf hear

He learnt his lesson long ago
And now he blends with white light
Having a supernatural sight
Seeing into the future
Seeing into the past

He understands human emotions
He understands passion and devotion
His arms wrap around the world
Your prayers are always heard
His spirit destiny for the world

He gives love without reward
He runs every good cause
Every charity his ambition
As he wakes one morning and gets in his car
Starting the ignition

THE THIEF

The thief knew the good Samaritan
The thief knew him the one
Knew the good Samaritan sent by God
But the thief felt no love
Only anger and material greed

Money he did want and need
Prepared to watch others bleed
The attack, the murder
The pain and the fear
Not yet knowing justice near

The thief never a good Samaritan
The thief with no heart
And no respect or quality
Doing poorly in education
Doing poorly in regular life

So when he bumped into
The rare good Samaritan

He knew God his enemy
He knew God would steal
His long term thieving skills

So he got revenge on God
Putting a bomb in the car
The only desired object
The good Samaritan treasured
But would now would use and die

THE NEXT CHAPTER

But God knew all this
And forgave the thief
The good Samaritan
Safely in the beautiful heaven
Singing with all the beautiful angels

A heaven free of blood and fear
A heaven with blooming flowers
Magical fairies and colourful mermaids
Heaven full of real love and rainbows
Where only happiness is found

Sending love from above
Knowing his good Samaritan
To feel a holy relief
That justice would be served
Of a life the thief did not deserve.

The Angels Are Singing

Angel feathers scattering across the ground
Angel feathers leaving a legacy
Of the lord above
A soul designed to love
God sending down his white doves
From his luxurious palace above.

The angels are singing
Love God is bringing
Because the angels
Sing glory to God
The angels free all from pain
Where they make the mad sane.

Angels sleep in pure white light

Love an eternal emotion
They do not deny or fight
God an ocean of consciousness
Cleansing white light
An energy not disappointing
Helping all to fall asleep at night.

God creating sponges
In his heavenly bath
For angels are like bubbles:
Giving a scent of perfume
Where there is no fear or doom
And soap destroys that bad smell
Gone: and none too soon.

Joy of the toy
When human that angel
Never to hurt another
Never to twist things around
Or seek out and destroy
Because love God does employ.

All the angels to sing
Walking with the king
Their mortal life of pain over
Their wonderful new lives
Lucky like a four leaf clover.

Angels to be God's immortals
Sending messages
Of hope and unity
Sending a message
That love is always enough
Forgetting tough love.

This Is My Religion: 2022

Before I could kill someone
I would have to kill myself

I wouldn't be able to sustain:
To handle hell's curses

Instead I would turn to God:
The Holy Almighty

My soul to be taken
Through the gates of heaven

Where glorious white light
And angels with vast wings greet me

Where great gifts are given
And soul deep happiness is made

My soul cleansed and redeemed
Having found true redemption

Fate, destiny and glory from above
To protect my soul with love

And on the third day after my death
I am resurrected

And the devil will ask:
'Why didn't you kill for me? '

And I will say to him:
Because I am a traitor too.

Nobody Is Drawing Wine From This Blood

Nobody is drawing wine from this blood
Nobody is going to steal my love

I am in a room all alone here
Yet I have no boundaries, hold no fear

I start the inner fire
I create your all consuming desire

No vampire feeds from this neck
I always know what comes next

I know the future and the past
I know the present moment

I am nobody's victim
I am never left drained

My blood never turned into red wine
Where people celebrate as they dine

But no one celebrates me:
To my mind only I hold the key

I create pure unadulterated gold
But never turn into unmoving statue

I wander the four corners of the world
And leave every stone unturned

I look to Mother Earth for protection
Never relying on winning an election

I don't need power and control:
I don't need to be a president

Simply said, only I hold the key
To my mind, body and soul: only me.

Word Factory

Many words pass through my mind
Words like school shoelaces I must untie
Like upsetting childhood memories
That so forbiddingly unwind

Memories never forgotten
Memories never to change
Memories to sometimes haunt
Memories sometimes simply unwanted

Like a curse words of evil flow
From the depths of the Fire God's
Evil realm not seen from the surface to deep below
Souls haunted and tortured until the burden of chains they tow

Stories written by a servant of the Fire God
Stories written by a servant of the Holy God
Stories written by a servant of the human race
Stories written to show a truly ugly face

I travel from place to place
With memories I shall treasure
Rather than dread or replace
For I am truly beautiful: written upon my face

Sometimes I stop and think
I don't know if I can handle
Dirty dishes in that old kitchen sink
The dining room table also cluttered

But I sit in front of this computer
I write confused and tangled words
My imagination a paradox
Reflected in all my fictional characters

And so the word factory reveals itself
And English Literature does increase my wealth
But I live for stories and people:
People who read my stories with great interest.

I Wish I Were In Heaven

I'd die to be in heaven
I would search the ends of the earth
I would search through time
I would search through the universe
To find the mysterious place
Every religion calls heaven

Where this strange place is
I will never know in this life
Maybe my soul cursed
To suffer having blood
To suffer pain of all kinds
The human condition being what it is

I know how I was created
But where I was before I do not know
And maybe it is best to not know
Secrets of the soul
Best kept as secrets to the world

But I do feel love
I do have affection and respect for others
I do know to never break the rules
Knowledge from somewhere
Before being born this person
Wherever that place was
Only memories of strange darkness

I see a world that cries at night
A world people born to suffer in
A world similar to the devil's hell
Perhaps life written by the devil
Every suicide the devil's work
Where he watches the weak hurt

I know I am no different to others

My heart without any lovers
My heart yearning for love
My heart yearning for care
My heart yearning for affection
My heart empty of that special someone

But I go to church and pray
I find enlightenment with every day
The sun rising me in the morning
And the moon helping me sleep at night
My life changing and becoming
A spiritual journey to redemption

And I do repent against hell
I know I feel much better without its pain
I feel much better without the heat
I feel much better without the pressure
I feel much better without the blood
I feel much better without the fear

I look to the sunshine blue sky
Seeing angels sleep on white clouds
Knowing I can be one of them
And find heaven where I've been all along:
Earth

Because I had been blind
But now I see the treasured white light
Knowing I am no longer blind
And become thoughtful
Caring and always kind.

Memories In Water

Water ripples across a clear fountain blue,
Pennies the wishes of a new yesteryear,
The waves of the ocean washes its tide,
Taking with it the sands of oysters still,
The ocean deep, the blue as dark yet,
Getting darker, the ships of yesteryear living with regret,
The water only remembering the cutting of the ships,
As they cast over their nets.

Water falls from a sodden sky,
The shape of the tears to gather with the tide,
The deep of the water: silk to the skin,
Shall bury itself deep into the sands of time.
The tides of the ocean with its bare seas cries,

The forgotten memories of another time,
Telling its tale of each fisherman it brought with its tide.

Each teardrop of rain the clouds bring with grey skies,
Shall dampen each sunshine ray,
And with joy bring a rainbow to shine,
The rainbow in joyous colour opening up the sky,
The clouds forgetting each tear it had fallen from the sky,
Opens up its gaps, the sun's rays spreading wide,
The stillness of the water once again reflecting the light.

Blue Candy

Dots of light scatter across the view,
From a distance I'm closer to the view.
The water moves as the boats remain silent in the view,
The screams from the park sheltered by the moon.
Blue firemen spread their heat,
The powder now a liquid with emotions to defeat.
People fire their souls as the rides end their attack,
Blue candy waiting inside them to react.

I travel along the water through my mind's eye,
Remembering myself with blue candy's tie.
I look to the park: distanced from the view,
The view ending with my eyes looking to the moon.
I see no clouds as the fire spreads inside,
Desire blue candy hitting in all minds,
Raw emotion no longer hidden inside.

Blue candy burns inside my mind,
The powder waiting to leave my past behind.
Blue candy fires as it heats like the sun:
Once inside it cannot be undone.
Every line is stirred under a darkened moon,
Burning desire blue candy's monsoon.
Like fire I call blue candy to defeat,
I, lying alone in a city's white light heat.

I Don't Want To Sleep In The Snow

I don't want to sleep in the pure white snow
Not when I have a beautiful apartment
I don't want to sleep in the cold snow

Not when a comfortable roof over my head
Protects me from the bitter
And incredibly harsh winter snow.

I don't want those snowflakes
Falling upon me in winter darkness
Where my body would freeze
From the harsh winter snow
Those months where nature
Hibernates and waits for colourful springtime.

No matter how pretty and romantic winter
My apartment always protects
Me from winter's cruel coldness
My stylish apartment protects
Me from its supernatural elements
And its enchanting allure.

With all of the people homeless
This bitterly cold winter
You have to pray they find warmth
And give money to homeless charities
Because it could be me:
All it takes is a missed rent payment.

All it takes is an unauthorized
Day off work, your employer
Quick to find a different worker
And you can't afford to be sick
Knowing you don't want to sleep
In the winter on those old church steps.

I Don't Want To Sing

I don't want to sing
Even if I had the voice
I wouldn't sing in public
I wouldn't sing in front of friends
I wouldn't sing in front of family
Except for 'Happy Birthday'.

I have no musical talent
I can't play a musical instrument
I can't read or write music
I have no desire to perform music
I have no desire to dance to music
I have no desire to host music shows.

I like watching music videos
But I wouldn't choose to make them
I like listening to pop, rock and jazz albums
But I wouldn't choose to record them
I like watching celebrity interviews on YouTube
But I wouldn't choose to star in them.

I am just your average Joe and Jane
I am just ordinary and anonymous every day
I am just travelling along the busy road
Whether by a private car or busy bus
I have no fame or fortune
And am very happy to be this way.

When Your Cat Scratches You

When your cat scratches you
You know you're in trouble
Do these things come in three?
And you hope your blood you don't see
For an excited cat is a dangerous cat.

Never walk into a tiger or lion enclosure
Knowing big cats beautiful but dangerous
Better to see through a human cage
Perhaps at the New Zealand animal park
Their close-up to big cats experience safe.

Realizing animals beautiful but dangerous
Does perpetually protect humans
From animal encounters and attacks
Although animals have been known
To come to the rescue of people.

Like a pride of strong four lions
Rightfully scaring off a group of men
With unknown reasons attempting to abduct
An innocent six year old girl
But the girl later found safe with her lion saviours.

Other animals known to save human lives
All documented on YouTube videos
Animals to be treasured and protected
Even when the lovely neighbour's cat
Scratches you accidentally in excitement.

And many believe animals to have souls
Animals deeply clever and intuitive

From domestic pets to animals in the wild
And we do take care around any animal
And have a deep respect for their power and allure.

Cheap Tart

Jealousy is the name of the game
Her sexy supermodel body
And unique face like a work of art
Attracting the mature older gentleman
Those beautiful princess women
Always top of popular fashion society.

Intelligence is the name of the game
Her brain that of Albert Einstein
Understanding scientific theories
And complex facts and figures
Those genius princess women
Always top of the class.

Pride is the name of the game
Her personality self protecting
Never putting herself down
Gaining real respect from everyone
Those confident princess women
Always leader of the pack.

Love is the name of the game
Her sexuality threatening
Insecure and jealous women
Women who should be her:
Labelling her a cheap tart
But she is simply true to her heart.

Respect is the name of the game
Her sexuality causing a backlash
Insecure and jealous women
Women who lack passion in their lives
Labelling her a cheap tart
But she is never a tart:

Because she is simply a woman
Who celebrates herself and her heart
Never stupid and always smart.

Stealing From The Thieves

Sitting here listening to Maria McKee sing
'Show Me Heaven'
I wonder where heaven went
Why there is only hell
Criminals playing the game well.

We are only stealing from the thieves
We aren't taking from the innocent
The world vast with its evil
The world vast with its beauty
God the creator a mystery.

We move, we weave, we deceive
We forever wonder and wander
What to buy as our next purchase
Where to travel on that exotic holiday
Private airplanes where we pay over a grand.

We feel relief with every paycheque
We celebrate our never ending wealth
While sending postcards saying 'Wish you well'
To our fools: those who dare take from us
And cause us distress and trouble.

We remember the painful trauma
Before our luxurious lives
Sitting in hatred and anger
But now we walk away smug
Knowing we need no drugs.

We attract but repel
We are beautiful but nasty
We are rich but common
We are musical but realistic
We are real but live in fantasy.

Stealing from the thieves
Making us super lucky
Them having no awareness
Of our delight and soul deep happiness
Where they are all invited to my party.

Everybody Cries

From innocent young childhood
To mature and deep adulthood
My wonderful parents taught me
To value and treasure myself
In spite of the misery in the world

They taught me all I know
They gave me the emotional building blocks
That make up complex adult life
Building blocks that always protect me
From others damaged minds

I look after number one
I look after my reputation
I look after my appearance
I look after my soul
I look after my health

But I do sometimes cry:
I think everyone cries
Everyone hurts as R.E.M sang
A song more important than money
A song written from experience

I don't regret my life or who I am
Even when problems arise
But they are never a surprise
Because I am not sorry to cry
Because I am very much alive.

The Superhero Trilogy

CAPTAIN SANITY

Captain Sanity: also known as Angela
Having lived a hard life in the Bronx
Taking all the breaks life can give
Knowing she must make a huge effort always
In order to be happy and just live

Without virtual insanity
Without emotional blackmail
Without domestic violence
Without poisonous cigarettes
Without verbal abuse

Working for the mental health services

Angela - Captain Sanity
Shows others how to live
And unconditional love she does give
Without expectation of reward

Angela emotionally strong
Angela with a big and generous heart
Angela that to the world does belong
Angela always the one that does steer
Angela fighting the internal fear

Showing courage and how to be strong
Showing how to face life and get along
Showing true love
Showing angels guiding from above
Showing faith, passion and hope

And in times of insanity
Captain Sanity does guide all in need
To stop the cut and the bleed
Forgiving others and spreading angelic love
Angela the Captain of Sanity from above.

IRON WOMAN

Iron woman without fear
Iron woman without prejudice
Iron woman full of muscle
Iron woman never lying and crying
Iron woman never abused

No one able to verbally abuse Iron woman
No one able to beat Iron woman
No one able to intimidate Iron woman
No one able to make Iron woman history
No one able to defeat Iron woman

Iron woman having once cried
Iron woman having once been a different person
Iron woman having once been emotionally weak
Iron woman having once been physically weak
Iron woman once silent when hurt: never to speak

Iron woman now with everyone on her side
Iron woman now happy to be who she is today
Iron woman now showing emotional strength
Iron woman now showing physical strength
Iron woman with a loud and proud voice.

SPIDER WOMAN

Next to Spiderman is spider-woman
A woman no stranger to spiders
Having held a seemingly harmless spider
And then it biting her with its fangs
An ordinary woman transforming

Into a red costumed spider-woman
A woman able to do acrobatics
A woman able to throw a punch
A woman able to shout at aggressors
A woman able to defend herself

Spider-woman never a victim
Thanks to that biting spider
Spider-woman always above others
Thanks to that biting spider
Spider-woman always attractive to others

With her physical and emotional strength
As she goes from place to place
Hiding - sometimes - like a spider
Inside the shadows to pounce and attack
Emotional intelligence that does never lack

Spiderman to love spider-woman
Two superheroes perfectly matched
Every criminal caught
Every criminal found out
And rightfully punished

Together Spiderman and spider-woman
Make the dream team
The criminal world dreading
Their impact as they stop crime
Making those guilty pay by doing time

The world protected as long as superheroes rule
Including teaching kids to protect themselves at school
Follow their dreams and achieve
For them and their future
Where they make it happen and also use a computer.

Every Day Of The Week: My Life

MONDAY

The official working day is Monday
Getting quickly washed and dressed
In the tiring and lethargic early morning
The bathroom always cold that time of day
Whether scorching sun or cold snow
Temperatures above or below
Hot in the sweaty summer
Freezing cold in the winter snow
Frazzled parents and noisy kids
Packed in the predictable car ride
Whether the car large or small
Whether kids happily short or tall
The school day begun on Monday
The office day also begun on Monday.

TUESDAY

Another day in the busy office
Keeping paying the regular bills
Keeping paying for the kids lifestyle
Now settled into the working week
No matter the weather outside
No matter wanting to lie in the cosy bed
And resting your weary head
Not being part of the world
But from a distance viewing it instead
Through the house window
Watching the world move itself along
Seemingly easily but appearances deceptive
And food is put on the table
Orange juice and toasted bread
Even a hash brown and fried egg
That settles normal morning hunger.

WEDNESDAY

The day the magnificent magazine
Just 17 is sold in the corner shop
Every Wednesday like clockwork
Sugar magazine sold every month
Also like clockwork
Teenage girl magazines exciting
When read with friends at school
When pored over at night in bed
Relishing fantastic fashion
And brilliant beauty advice

Looking for the perfect Collection 2000 lipstick
From a nearby miscellaneous shop
Wanting that particular pink lipstick
And also loving free gifts
From them: like popular lipsticks
Or tantalising tarot cards
Even supplement magazines
Of the same magazine:
Whether short stories
Of real life or even fiction
Or anything else for that matter
Helping teenagers sort their lives
And find their place in the world.

THURSDAY

The day is social club day
And also in the evening
The community centre popular
With many people of the town
Enjoying sitting with good friends
Talking and laughing, quiet and loud
About relationships and situations
That seem to always crop up
But friends will be friends
Offering support and loyalty
Never betraying confidences
Or hopes, promises and dreams
Told in secure secret
Making connections with people
Bonding and caring
No one needing to be upset or lonely.

FRIDAY

Today is grocery shopping day
Going to Tesco and purchasing
Various foods and beauty items
In the comfortable family car
That makes doing the shopping
Seem like the distance much less far
Also eating a pleasant lunch
And spending time in the sunny garden
With a visit from the neighbour's cat
She laying there having a well deserved nap
In the evening to eat fish and chips
A traditional thing
Started from years and years ago

For reasons I don't know
But every family has their quirks
And their habits:
Not all loving families the same.

SATURDAY

A typical Saturday morning routine
Is drinking rich caffetterie coffee
And eating a peach and passionfruit yogurt
In the designer dining room
Vibrant and deep paintings on the wall
That many do recall
From their artistic studies
Even when underneath the moon
With the warm morning sun
Pouring through the windows
And fresh air waking the senses
To later go clothes shopping
And spend hard earned cash
Buying stylish dresses and skirts
Buying men's wear for dad
And funky and cool presents for the kids
Also wandering around beauty aisles
Admiring the pretty lipsticks
And skin smoothing foundations
And smelling absolutely gorgeous perfumes
That enchant with their seductive scents.

SUNDAY

Having a long lie-in on a Sunday morning
Then eating a full English breakfast
Having a luxurious bubble bath later in the day
Then going on the bicycles
With a sturdy safety helmet
Cruising around the parks in town
And past the freshwater rivers
The fields green with summer grass
Not complete without vanilla ice cream
Almost a scent of nature's perfume
Enjoying being young and free
Not living in forever misery
To then later eat a roast dinner
And wash up dirty crockery afterwards
Clearing the kitchen of inevitable mess
And leaving the night to go on
Then start again on Monday

Doing it all again and with grace
Knowing the soul is wise and strong.

Apartment Life

I live the apartment life
Where my quiet neighbours
Look through curtained windows
And know all that they can see
But this does not bother me.

I live the apartment life
Going out and about
Where I paint the town red
Boredom when alone indoors at night
Entertainment important to my life.

I live the apartment life
Where I have the perfect interior design:
Peach lounge walls, white bedroom walls
And a gorgeous beige fluffy carpet
My apartment floor soft under the feet.

I live the apartment life
Where my bookshelf contains various items
And my collection of books are showcased
Being a self confessed book lover
Having read famous novels for years.

I live the apartment life
Going to the office every Monday
Having a lie-in every Sunday
For that day is my fun day
And my routine rest day.

I live the apartment life
Eating out and eating in
Cooking for myself with Hello Fresh
But also going out for dinner
Enjoying all the culinary delights.

I live the apartment life
My neighbours also in their apartments
Guests to mine coming and going
Residents coming and going
Month after month, year after year.

I live the apartment life

Airing out the rooms every day
Always washing up and washing the laundry
Always keeping my home pristine
My apartment aesthetically pleasing.

I live the apartment life
Going daily on my computer
Working online as an online legend
And keeping up appearances
Knowing myself a public figure.

I live the apartment life
Inviting fun people over
And serving mostly soft drinks
And just entertaining friends
No one getting drunk however.

I live the apartment life
And will never live in a house:
Because my apartment is home
And I know I am not friendless or alone
For apartment life is my true home.

Clean Queen

I am the clean queen
Scrubbing the bathroom tiles
Mopping the bathroom floor
All this cleaning done
Something I never ignore
For it seems a chore
But cleaning you must
Never ignore.

I am the clean queen
Scrubbing the kitchen tiles
Disinfecting the work surface
Washing up the dirty crockery
Taking out the rubbish
Recycling any household
Used items I can
And mopping the floor
Cleaning I never ignore
For a dirty home
Is a sign you're poor,

But no matter the bank account
Having a clean home

Shows great pride
And you live in a house
You don't have to hide from view
From strangers or friends
Their opinions on which you depend.

So be a clean queen
Live hygienically
And environmentally green
Because your home
You know, every day you see
And you will be happy
From spring to summer
Autumn and winter
And every moment in-between
For I am a clean queen
And hold the golden key.

Not Mine To Begin With

Even if I had all the riches
Of the world
That money would still
Not belong to me

It wouldn't be mine
Regardless of whom I knew
It wouldn't be my success
My glory and adoration
My popularity
My achievements
My golden crown
My worshipping fans
My lifetime plans

Because none of it
Would have ever been mine
The old tales of the golddigger
Dreaming of a life of money
Dreaming of a life of luxury
Every day fair and happy
Winning the lottery
The lifetime dream

But life is cruel
Especially to me
Never getting more than I need
For my soul

Does perpetually bleed
Love a drug I need

But drugs destroy the mind
It hallucinationally
Leaves nightmares
Where you wake with a scream
Your money tricking you
With what you don't need
Yet want, yet desire

The material world
Burning in greed
Burning with envy
Burning with jealousy
Burning with hatred
Burning with evil
Burning with violence
Burning with murder
Burning with rape

And everything must go
God I must know
For I am to be taken
From this material world
Where only the silence of angels
Can be heard.

This Walking Skeleton

This once walking skeleton,
Only ever wanted to be slim,
So I went without food,
Determined never to be,
Ugly and fat,
Or a greedy pig,
That stuffs her face,
With chocolate and sweets,

But these emotions go deep,
My body losing fat and muscle,
As the tiredness from lack of food,
Makes me go to sleep,
No energy to stay up and party,
Friends seeing my body,
And telling me to eat,
When before they said,
I would be fat if I ate my greens and meat,

For I had been normal once,
I ate my breakfast and lunch,
And I had dinner with hunger,
Only too happy to eat burgers,
Chips and whatever else was there,
But I got curvy hitting my teenage years,
And others noticed,
The girls calling me fat,
Teasing me as they looked,
My lunchbox with its sandwich and apple,

So I decided to throw away my lunch,
I only had an apple and maybe an orange,
I would read diet books and cook,
Pretending I loved food,
And people praised me: at first,
And I lost a lot of weight,
People seeming to respect me,
For I had let greed leave me,
Or so I thought.

I became too skinny for them,
People encouraging me to eat,
But I remembered what they said,
When I ate greens and meat,
They were just jealous,
For I could look good in a bikini,

But my parents did not agree,
They sent me to an eating disorders unit,
At first I would refuse to eat,
And when I did eat,
I would exercise in secret,
I could not vomit up my food:
I would be found out,
So I slowly gained weight,
And was told I had a healthy,
Complexion again,
But the bullying and old fears,
Always creep up on me,
Those girls calling me a pig,
For I had been healthy and happy,
And they were jealous:
At least, that's what I know now,
So I eat my breakfast,
Lunch and dinner,
Knowing I don't have to be,
A walking skeleton to have worth,

And be respected by my peers,
No matter what society says.

Never Your Product Of Misery

No matter the past I faced
I refuse to be your product of misery
I shall keep my friends
Staying at my side
For I have plenty of pride

I look after my inner and outer self
I refuse to be your product of misery
I shall have success
That time won't end
And niceness I do not pretend
For I am real
And love I never fake
And love I never take

I will share my opinion
Whether loud or quiet
Across the room
My thoughts and opinions
To be forthright
And never held back in fear

And if you come near
Your body a weapon
I will promise you
My body is also a weapon
For my personal space
Is truly mine and mine alone
Everywhere my palace
My opulent home

Every group, room and stage
Belongs to me
Where once I felt fear
Yet I am confident and set free
Never to be your product of misery
Never to let you win
Or live a life of crime or sin

So if you're looking for competition
You've got it
While I won't destroy you
Because I am the creator

Rather than the destructor
My soul all the colours of the rainbow
And I can never be left blind
My soul never black or white

And I save others, I am nice
So mess with me
And you won't have to look twice
My body wound up for a fight
As I am protected
By the above white light
My smile never vanished
And my pride never destroyed
No matter tactics employed

I am the ultimate
I am the chosen one
Life where I do have some fun
My decisions keeping the morning sun
Rising for everyone
Life easier for the world
Where prayers are always heard
No one a product of misery.

Important Questions

If you got lung cancer
After years of smoking
Would you look back
Thinking you had been cool?
Or would you feel like a fool?

If you were being bullied
Would you look in the mirror and care
About your clothes and makeup
Or the latest fashion magazine?

If you were in hell
Being tortured by the devil
His goal to leave you emaciated
Would you really care
About the latest reality TV show?

If you cut yourself
When shaving your legs
Would you care
About how stylish your bathroom?

Or how long your legs?

If you were raped
Would you wear short skirts
And wear high heels
On nights out
To attract men?

If you were lonely
Would you care about your date
Ticking off a checklist
You compiled years ago
To select the perfect person
From their hairstyle
To their relative appearance?

If you were scared
Of being evicted
And sleeping in the snow
You'd put up with evil too
You'd also stop the perfect interior design
You would also cry
And be alone with your thoughts

No longer caring
About fashion or makeup
The other women
Not understanding pain
Their selfish ways
To leave you burning with the shame

Because they sail
On their yachts and boats
They ride private airplanes
And own quarters on trains
Their high fashion cars
Socializing with the stars
Jewellery and lifestyle too
Parties and gatherings
To be in great abundance:
Lucky them

But I am not them
Because I am real
And know in my heart
There is a great deal of love for the people
The whole world over
And that love I won't let anyone steal
My confidence incredibly genuine and real
My personal power no one to ever again steal.

Everything Always Goes Wrong

I don't believe in happiness
Everything always goes wrong
Making a rich home life
And having money in the bank
You think you're free
But in reality you're not

Friends betray you
Family betray you
Strangers betray you
Society betrays you

Society sees your relationship history
Your fights and feuds
With former friends
With former partners
With former neighbours

You make wealth for yourself
You make good health for yourself
You do all the right things
Your life is happy
As you wash the dishes and sing
Along with the radio

But your house
Becomes awash with violence
Or fear and other abuse
And you end up dead in the ground

Your dead body found
By the police, and shocked
Neighbours that never forget
Your lost life
Not saved by that beer and cigarette
On those lonely, lonely nights
After those fierce family fights

Where you thought yourself
Lucky to have money
Lucky to have those people
In your precious life
But you try and try
Not wanting to say goodbye

But all you were

Was a battered wife
Or a murder victim
Left dead while others
Live their lavish lives
Not knowing what you lost
The day you were buried in the ground

So I don't trust happiness
From experience if you must
Where others I knew
To never rely on: never trust
Because happiness doesn't last
And life is always changing
Leaving time going fast

Where you have to search
For justice from those criminals
That stole your riches
And stole the life
You had truly treasured
And should have lived to old age.

No-One Can See You Cry

It seems the walls have eyes
But no one can see you cry
No one can see your upset and tears
While you taste your ever going fears
Time doesn't erase

And you wonder when happiness
Will take the tears place
You wonder how they know
Your private business
They have no right to know

Their spies to follow you
Invading your personal space
Trying to steal your personal power
That you've worked for years
To keep in your night time sleep

Your dreams and ambitions
To be soul deep
But your pain loses your inner sight
And your peace of mind
Even when you're always nice to yourself

And when the clock hits night time
Your eyes run with the tears
Even though you tried all those years
And you feel they can see you cry
Even though in the day your eyes stay dry

But your pain is their gain
Unable to hide your tears and fears
Tears pouring from your lonely eyes
Never ending until you fall asleep
But they are the blind ones

Because with the tears
You have become
Stronger and emotive
You have become kind
And now you're forever wise.

Golddigger

Pleasure she is an expert in
Her life full of sexual sin
She does offer visually graphic
Services that appeal
To both mature men and women
Her methods designed
To seduce with confidence

She attends sensual sex clubs
And many other night clubs
Hoping to meet a rich and powerful
Man to seduce with desire
Leaving passion to climb higher
As the night progresses
Their physical excitement evident

She is a material girl
And lives in a material world
Loving fashion and glamour
Spending nights wandering
Around town in those fabulous heels
Knowing herself the upper class
Alluring and self sufficient golddigger

With a soul deep Christian name
Once men meet her they lose their shame
Knowing what she really wants

Excitement, passion, glory and fame
No two days ever the same
And colourful designer clothes
Are the golddigger's business

Going for the mature and older man
She does all she can
To look pleasing to the eye
And celebrate her youth and beauty
That does fade with inevitable age
But she is clearly a mature woman
A golddigger knowing the ways of the world
Money and social power always on her side.

I Need Alcohol: Nightmares And Alone

The night falls upon my lonely heart
Memories play their cruel part
People Chinese whisper
People chase and goad me
And spit on the autumn ground

Time moves slowly
New memories are made
While I live my life afraid
Anxiety never ending
Unless I ease my blues with the bottle

The old drink does ease the fear
Drinking does take me away from here
Away from the nightmare
That is my constant burden
As if I have blood on my hands

Years and years wasted
All those variety of drinks tasted
From gin, beer to vodka
And girlfriend cocktails
No idea of my incessant need

To walk and breathe intoxicated
Red wine to white wine
And every other drink
My mind numb
With no need to think

Brandy like candy

Sweet on the tongue
A drink not designed for the young
An addiction to ultimately destroy
Like a hitman's gun

Others notice me relaxed
Not telling me about the tax
That trying to ease the burden with drink
Getting drunk instinct
From relatives with the same problem

But I am in denial
I believe no one knows
But deep down I know it shows
For my love affair with alcohol
Is just how my life goes.

New Always Becomes Old

You go to the busy shops
You buy everything in sight
From hats, jackets, scarves,
Skirts, dresses, shorts and trousers
Shirts, sweaters and cashmere
To stockings, tights and socks
And to makeup from vibrant lipsticks
To skin matching foundations
To eye-catching mascaras
Eyeshadows and face powder
Every luxurious makeup item
To be sold on the shop floor
Designer clothes and makeup
To be worth a lot more
When compared to the sale items

Then you buy your cars and large house
You buy colourful new carpets
New rugs, lamps, kitchenware
New everything for your kitchen
New wallart for your lounge
You pay for expensive holidays
You pay for expensive mini breaks
Money made whatever it takes
For in life you catch all the breaks

Yet the clock keeps moving
The seconds don't stop
The minutes don't stop

The hours don't stop
The days don't stop
The weeks don't stop
The months don't stop
The years don't stop
The decades don't stop
The centuries don't stop

Your riches to become history
Your way of life to others a mystery
Your riches just a memory
Your luxuries just a memory
Your expensive shoes
Just a wonderful memory
Of days and nights you cannot get back
Even with your endless photographs
And your timeless films
Everything new becoming old

With time your tale told
Your memories pure gold
Your soul never sold
If you don't accept fool's gold
For even though you are old
Your love can never be sold
Given away or wrongfully stolen
Your memories happy and golden.

For the universe does never forget
And your wise decisions
You shall never regret
Knowing new becomes old
But you are always in existence
Yourself your only guide
Letting go of temporary materials
That left you yearning yet blind
But your eyes now open
Where peace you have in your stride.

Miss Vanity

Forget your innuendos
You're so vain
Carly Simon wasn't wrong
Your vanity is a basic fact
That will break your own heart

You pretend your confidence

You magically hide your insecurities
Your fears and your stupidity
But your appearance is perfect
Like the cover of a fashion magazine

Your foundation is flawless
Your hair expertly coloured and styled
Your whole look perfect
And pleasing to the eye
But it is all a devastating lie

Your soul is toxic
Your heart empty and cold
With every nasty tale told
You fake niceness
But you insist you are actually nice

You act like some kind of superstar
You spread vicious lies
Thinking you've won
That you shot the rabbit:
Shot that hitman's gun

You are full of soul destroying hate
With love you will never relate
Your soul dark and black
All those angry knives
Piercing your ugly back

You tell your innuendos
You tell tall tales
Your lack of love
Making you fail
Nastiness how you bond

But you haven't won
I will fight you to the end
I will banish your demon soul
To the gruesome hell
Where the devil does his job well.

Eating At Midnight

The full fridge beckons
The clock saying it midnight
The comfortable bed forgotten
Even with its tempting
Fluffy white duvet cover

And sleep inducing pillows

She steps onto the bedroom floor
Looking at the moonlight
Shining from the empty window
Her heart as empty
As her yearning stomach
Determined to go without food

The small light in the kitchen
Is turned on, illuminating
Her pale face and hungry mouth
Thinking about the jokes
Her weight makes everyone say
No realization of the emotional pain

Her large and curvy body
A curse and point of ridicule
Born to be fat and ugly
Born to be mocked: an ugly duckling
Those others jeering with scorn
Her crying heart bruised and torn

Her close friends tell her
That these people are best ignored
That they are just empty and bored
With no value of their own selves
Their own struggles the same
They too feeling the pressure

Feeling the shame
Feeling the never ending pain
Looking for a scapegoat:
Someone to torture
Someone to blame
But she feels heartbroken

The food in the fridge devoured
Soon the kitchen scoured
No evidence of the binge
And the necessary purge
Vomiting up food a vital urge
No one to know her secret

But she becomes thinner
Turning into a winner
Now always being praised
Now apparently out of that cage
Free of the curse that is being fat
And friends that did lack

Whether people find out
Her secret habit
The binge and purge
She is a victim of society
Who declares the thin
To be the ones that always win

But she has a heart of gold
In spite of what they stole:
What being fat made happen
The fear of fat severe
But people do have ears
The therapist to understand

Everything they hear
And teach us a way
Out of soul devastating fear
Our pain obvious and clear
As our eyes rain tears
Help the therapist does provide:

For those with eating disorders
Are never alone
And have nothing to hide.

The Neighbours Are Talking

The neighbours have seen the rubbish
The family produces
They've seen the muck
Echoing the resident's mind
Through the bags and bags
Of worthless rubbish in the garden

They have heard the angry shouting
Through the open window
Of a family at war
The drama and problems
Seen all too often before
Neighbours spreading the vicious gossip

The neighbours dread to see inside the house
They dread to see the mess and filth
The useless clutter and rubbish bags
Littering the abandoned hallway
The pile of dirty crockery
In the messy, uncared for kitchen

The family unfortunately torn apart
As if no love in the heart
The family living separate lives
One family member in an apartment
Another living in luxurious London
The father living sadly alone

For conflict lost the connection
Conflict threatened the protection
All family members needing
To see inside their true reflections
But a new family has direction
For wonderful grandchildren born

The father now a grandfather
The grandmother sadly deceased
But love does never cease
And future generations
Will take stock
Before their own family line can go to pot

And the neighbours did talk
But the family has expanded
Children born to a proud grandfather
For good does always come out of bad
And happiness happens
For new generations to feel glad

They've got their own family home
Where they reap what they sow
Even though the hard times
The world does endlessly throw
But relatives forever united
For blood is always thicker than water.

Are You Dating A Narcissist?

The world is stone
He tells you what to do
He throws many stones
He tells his boiling rage
His heart in a metal cage

He blows hot and cold
His nasty tales told
Your diseased broken heart
In his cold and empty grasp

When once he loved you

But he changed
Or grew complacent
Your relationship his mission
Of how society sees him
Although him being a narcissist

He is easily hurt
Where you're glad
In the daytime he's at work
Dreading when he returns
And money you never dare burn

His evil and selfish ways
Even with friends and family
Not knowing they know
His narcissist ways
People walking on eggshells

But he has thin skin
And doesn't let love in
His soul in mortal sin
Even though in life he believed
That he looked down from above and did win

But he cares nothing for others
Trying to change him pointless
He will never be the better person
And will never admit
To being a soul crushing narcissist

Accept you will never change his ways
And realize your two options:
Accept him as he is: he will always be vile
Or finally ship out where you can smile
Now in a life free of hassle and stress.

Left Out In The Cold

It started with odd girl out
An innocent 14 year old girl
Realizing the teenage years
To be of hardship and tears
Every day in that jam packed class
Filled with her internal fears
Her doom crystal clear

Soon seen as shy and timid
Shunned from her peer group
Told she to be useless and worthless
Told dreams would never come true
Told life nasty and unfaithful
And deeply cruel and unfair
Narcissist's taking that dare

Of stealing innocence
Of stealing peace of mind
Of stealing emotional security
Of stealing happiness
Of stealing hope
Of stealing love
But never stealing inner grace

But now she is on the streets
The aggressors having won
With their underhand thievery
With their tricks and games
Leaving her broken and bruised
Leaving her alone and crying
Tears of a broken heart

They go to the cinema
They go to the theatre
They go to weddings
They go to birthday parties
They go on their yachts
They go out to restaurants
They go on exotic holidays

While she is left out in the cold
Left to feel the cold breeze
Sting her tired and weary eyes
And leave her having lost everything
Her peace of mind and money
Knowing they've got their
Successful and happy lives

It isn't fair and it isn't right
Where she now knows
She should've put up a fight
And protected herself
From their power games
And vicious lies
And painful sly violence

But now help is coming
To take her off the streets

Where she used to be meat
In a life full of deceit
Vicious lies and innuendos
New leather boots now on her feet
Where she stands strong

And doesn't admit defeat
Her truly old soul
Knowing her errors
Knowing her mistakes
Knowing her problems
Viewing herself from afar
Now being a soul truly wise.

Unfeeling Robot

Your heart is made of ice
You have to be asked twice
To be friendly and nice
But your soul cold like ice

You only care about power
You only care about your status
In society and to every stranger
You an evil mortal danger

To others and ultimately yourself
Where you only care about wealth
Your position of power
In society and each violent night hour

You spit on the unlucky poor
But it is you who is really the trash
Your money only borrowed cash
For you have no class

You don't deserve to be happy
You don't deserve wealth
You don't deserve good health
And I will never be there for you

Hope you never sleep in the snow
Hope you never know what I know
Hope you never have to reap what you sow
Hope your life doesn't blow

Psychopath, narcissist or sociopath?
Be honest and tell me which are you?

Hope you never have to choose
From the devil's painful torture chambers

You are an unfeeling robot
Is there any love in your heart?
I hope someone breaks your unfeeling heart
I hope all of Pandora's curses curse you

I shall never be your friend
I will never be there to the end
You I truly hate and truly loathe
And I hate everything about you

Never ask me for money:
You are on your own
So don't come begging
When broke: you're alone

I hope you love yourself:
Because I certainly don't
And other insults in my mind
Making me want to gloat.

Death In Paradise

Death in paradise
Murder does take its toll
Blood on evil hands
Mud smearing ugly faces
Dead bodies to be found in shock
Lying in the hot foreign terrain

Those guilty feeling the pain
Feeling the never ending shame
Police to thoroughly investigate
Murders in supposed paradise
Murders of unwittingly blind tourists
Tourists brutalised and all too dead

No matter how severe the crime
The killer is always caught
Put in prison to do deserved time
But the victim's family members
Only have brief snatches
Of the turmoil they suffer in prison

Tourists to have dreams
Of excitement and world travel

To take their bulging back pack
To go on boats, trains and airplanes
Believing the world safe
But a killer waits in paradise

The tourist to wander earth
Even with all its mirth
Believing murder impossible
That they'll return safely home
Instead buried in a foreign country
Never knowing their fate until too late

But justice will be served
And the murder victims
Now reside in the holy heaven
Their short lives never wasted
Their valuable time on earth
To be treasured and remembered

And now safety is paramount
To never go to private properties
To never accept lifts in a car
To never even deal drugs
Or go out in unknown territories
Or wander around late at night

Stick to the tourist roads
Stick to the tourist trails
Stick to public buses
Use your common sense
And have your phone with you
And never trust anyone

Lives having been lost
But the killer's life
They now to owe a debt
When they murdered the innocent in paradise
Where they grabbed a weapon
And nastily with a weapon crept

Blood on their hands
Impossible to wash off
No matter the soap used
Sweat on their backs
Impossible to wash off
No matter the soap used

Follow safety guidelines
And you'll return safely home
And know the world will

Always remember those
That lost their short lives
Because of the murderous guilty

People to forever remember
All those lost on their travels
To remember their humour
Their fun sides and their quirks
Their love and affection
To support families with sympathy

Who do remember as they grieve
Proud of what their family member
Did achieve by going to paradise
For facing the world with confidence
And reaching immortality
In the real paradise that is God.

I Wouldn't Get Far

If I tried to steal an expensive car
I would not get very far
I wouldn't be able
To work the controls
To drive the fast car
Like a man playing his guitar

If I tried to run away
I would not get far
Even if I fled by car
The unknown driver taking me
Somewhere mysterious and faraway
Somewhere happier to stay

But I am not in that expensive car
I shall never get far
Even if I tried to fake it
Even if I tried to make it
My own destiny in this lifetime
My own destiny written by the stars

I have to face my inner demons
Not run away in a fast car
To a place empty of emotions
A destination that is atrocious
A destination that is dead end
Where there is only pretend

Because I have to be a passenger
Not be the clueless driver:
Not crash and burn
With nowhere to go
With nowhere to escape
Losing control of the steering wheel

Because that expensive car
I never need break into and steal
My broken and lonely heart
To mend and finally heal
My emotive mind to always feel
And love I never need take or steal

And I used to run away:
That didn't definitely work
Even when I did search
But now there is some scope
As I sit a comfortable passenger
In a car going to a place called hope.

Official: I Work Hard

The alarm rings every morning
The clock saying it 7 o'clock
I get out of bed and shower
I get the kids out of their cosy beds
And they all quickly shower

Then it is breakfast time
Where I drink my caffetterie coffee
And the kids drink orange juice
I eat my strawberries and muesli
And they eat their soggy cornflakes

We all pile into the small car
The handy local school
The distance not too far
And soon - in a noisy car - we arrive
And my kids greet their classmates

I continue in the rain to work
Sitting in the busy office
Answering the telephone
Responding to neverending work emails
The other office workers also female

Then soon lunchtime arrives

And the nearby cafe thrives
My co-workers and I to dine
Our lunch perfectly cooked
And just tasting utterly divine

I get back to work and before I know it
It is hometime for my kids
My working day thankfully done
My day successful and busy
And now my kids are soon home

We all eat a tasty dinner
My kids loving their food
Even though sometimes in a bad mood
But that is seldom
My kids loving their young lives

Soon it is TV and then bathtime
Bubbles wonderful and sublime
My kids happily bathing first
Then at their bedtime
It is my turn to relish the bubbles

I work hard and I play hard
Working hard every single day
Because I am a top mum
And my kids are important enough
To indulge in happiness for everyone

Because I believe a happy childhood
Means happy adulthood
And a healthy psychology
Starts in childhood innocence
And prepares for harsh life

But I also work hard for me
To pay the bills and my house
To live my life in harmony
To live my life and be free
To live this life just for me.

No One Can Steal Your Colours

They call her 'Miss Fix-it'
But no one can steal her colours
They call the her a perfectionist
But no one can steal her colours

She had been foolish
But now she is a party girl
She had been innocent and young
But no one can steal her colours

She cried alone many nights
Yet always magical dreams
Take full flight through the black universe
Into a star filled colourful reality

She paints many canvases
She blends those primary colours
She creates imagination and depth
She creates radiant rainbows

Her heart beats red with passion
Her imagination is the sunny blue sky
The sun is her vibrant yellow
Green is the grass her pink flowers grow upon

She mended her wounded seams
She followed night time dreams
She painted vibrant rainbows
Across the beautiful blue sky

She had been a ragdoll
She had been an entanglement of yarn
She had been lost yet found
She has so much of which to be proud

She had her heart broken many times
Yet her heart continues to sing
Her heart big with its size
For her loving them is somebody's prize

She is a blessed angel, destined to fly
White feathers scattering from her wings
Her halo making happy hearts sing
And to the world joy she brings

No one can steal her colours
No one can erase her rainbows
No one can steal her love
Because she is an angel from above.

An Unplayed CD Collection

As the years pass
The CD collection grows old
Never played on the stereo
Never heard on the radio
Where once pop hits did hit ears and blow

Pop music acts, rock stars
All singing and dancing
And playing their legendary guitars
The choreography of stage performances
And music videos amazing

But the years don't stop
And musical acts never end
The once popular music
Stored in an old CD collection
That is now never heard

The owner of the deceased CD collection
Glad time doesn't stop
And some memories best forgotten
Best put down to experience
And just being young and foolish

Old music stars opening
Painful memories of the past
Yet some artists to create
Nostalgic remnants
Of lost loves and found loves:

Of friends come and gone
Yet worth gold for their memories
Their cold hearts once shining
With hope for the future
And faith in love and life

That unplayed CD collection
Unlocking times of adventure and wonder
Where Dewberry body spray was used
And Lynx Africa body spray loved
Creating such nostalgia and happiness

Music to be old time jazz
Romantic Rhythm and blues
Fad pop and rock acts five minutes of fame
Country music of the old days
Memories from every song remembered

And most women remember
Their harsh and turbulent teenage years
Where boybands raised the bar of popularity
Teenage girls in love with an image:
An image falsehood in the end

Those boyband albums happily
Forgotten and only living in the past
Teenage years sometimes a blast
Girls and boys the same at heart
Feeling themselves torn in two

Then there are the old jazz albums
Telling of times in mysterious jazz clubs
And parties of sophistication
Those older adult years
Recorded in an unplayed CD collection.

Greek Goddess

Sitting on the beach in a yellow swimsuit
Wearing dark sunglasses
Wearing pale pink lipgloss
Smelling of sunscreen and the sea
Strutting her stuff along the beach
Knowing that heads are turning

Sitting at the cafe in autumn
Dressed in a silver sequinned skirt
Dressed in a purple couture sweater
Covered - yet comfortable and stylish -
In the rain and cooler weather
And dressed in funky black velvet heels

Sitting in the Italian restaurant
At the start of snowy December
Autumn - and autumn rain -
Merely a romantic memory
With all the ghoulish Halloween celebrations
And colourful Guy Fawkes fireworks nostalgic

Sitting around the tree at Christmastime
The Christmas tree sparkling
With electric light jewel colours
Of blue, red, green, yellow, orange, pink and purple
Glittering the Christmas tree like magic
As Christmas presents are excitedly exchanged

Sitting in the busy church at Easter
Springtime glorious like a rainbow
With chocolate bunnies and Easter eggs
Children's faces smeared with milk chocolate
Adults kindly delighting in childhood innocence
Celebrating themselves with red wine in the evening

A Greek Goddess the immortal
Living through life itself
And celebrating in this short, brutal life
Yet magical with its broken dreams
Everyone with some regrets
But life is extraordinary in every way possible.

Mirror In The Moonlight

I walk into the dark of my bedroom
The gold mirror standing there deceptively silent
The moonlight echoing the reflection
Perhaps my true reflection
Where I have no knowledge
Of what I will see:
What I will correctly predict

The future always seen as a rainbow
After the summer rain
The future always seen as echoes
Of everything that happens today
Events colouring the world
Colouring the never ending days
And never ending nights

And I gaze into the mirror
Underneath the moonlight
Finding darkness yet delight
The darkness a wicked spell
The darkness of evil that contains demons
And the darkness that surrounds
Those shadows waiting to capture me

I see shadows and movement
I see my reflection a demon face
I see shadows spring and attack
I see the enchanting night:
The never ending black
Where I yearn to see differently
And see a soul that isn't black

But my reflection distorts itself
And I wonder if this is me
I wonder what other evil I will see
And how to repent
And finally set my soul free
For the evil darkness
Should be the darkness of the universe:
Shining glittering stars and galaxies of hope,
Wonder, enchantment and beauty.

The Nostalgia Of Music

Part 1

The nostalgia of music
Goes on forever
In the public's heart
Musical act after musical act
With genius musical scores
Musical notes sung correctly
Instruments played by experts

Years and years go by
Songs to buy on CD
And repeatedly play
From the musicians
That studied for their
Whole lives to create works of art
More to music than singing one song

More to modern music
Than standing on a stage
More to modern music
Than five minutes of fame
Quick paparazzi attention
Not guaranteeing
Forever fame

But musical acts
Etched in people's hearts
From decades of creativity
Creative album artwork
Genius lyrics and musical hooks
And charismatic stage performances
Musical artists making people happy

Clubs and concerts
Packed with excited fans
And just generally the curious
To find out for themselves
Whether they like the band or not
But giving it a chance
The performers do impress

The romance of an old CD
Even classical music played sometimes
But country music artist Patsy Cline with
An outstanding and melodic voice
The world has never forgotten
Music with soul deep enchantment
Music with magical memories

Back to country music
The most famous Dwight Yoakam
The most famous Nanci Griffith
And other amazing and incredible artists
Their work lasting forever on the radio
So many people feeling nostalgia
And a sense of romance

Music is part of the soul:
No matter the genre
R&B, soul, jazz and the blues
All capture my heart
Remembering my life story
With all songs ever recorded
And reminding me of my wonderful life.

Part 2

1950: Patsy Cline

Patsy Cline starting her career
At fifteen years old:
WINC Radio station a hit
And a high way up that career ladder
Next joining a band
Run by performer Bill Peer
Television broadcasts starting
Patsy Cline a star in her own right
Because "Walkin' After Midnight"
Sky rocketed Patsy Cline's career
In which Patsy was in full control
Did decide for herself and did steer
Her career taking her into the early 1960's:

A decade music lovers will never forget
The list of hits never-ending
After signing with Decca Records
Under the direction of the producer Owen Bradley
On the jukebox a Patsy Cline song always chosen
Always pressing play and select
The public not pretending
Popularity evident with every Patsy Cline song
That showed to the world
The music industry in which Patsy did belong
And her legend shall always remain strong.

1960: The Beatles

The most famous band on the planet
Formed in 1960 in Liverpool
Band members:
John Lennon
Paul McCartney
George Harrison
Ringo Starr

The biggest influence in music ever written
And legendary stage performances
Never forgotten with time
Their music charismatic and exciting
Influenced themselves by 1950's rock and roll
Music in their soul
Musical elements of classical music
And traditional pop
Ballads, psychedelia, hard rock
And pulling it off with 100% success
Their names remembered forever
From young teenage girls swooning
And the working man needing entertainment
The Beatles shall always be played:
Whether on YouTube or CD
The band breaking the record
Of most popular band ever created.

1970: ABBA

ABBA Swedish super-group
Formed in Stockholm 1972
A band where members
Agnetha Fältskog, Björn Ulvaeus,
Benny Andersson and Anni-Frid Lyngstad

Four members of a music group
That would go on to sell over 300 million
Albums worldwide and branch into film
Mamma Mia! Super-popular
A successful musical that toured worldwide
ABBA a band with a great deal of pride
Their music original and influencing
Groups throughout the music industry
Their compilation album "ABBA Gold"
To top the charts
Not forgetting the Eurovision Song Contest
Where ABBA won for Sweden in 1974
With their song "Waterloo"
A song remembered to this day
A song no one can ignore
And capturing such nostalgia
The 1970's life where people did dream
And hope for a better future
But still living their lives
Going about their daily routines.

1980: Sade

One of the favourites of the 1980's
Sade formed in London in 1982
The band named after the lead singer
Sade Adu: also known as Helen
Most of the members from Hull
In Yorkshire: a county beautiful
And music as equally as beautiful
Sade first album "Diamond Life"
An album with music brand new
To smash the charts in 1984
The most famous song:
"Your Love Is King" but their career ongoing

Releasing other albums:
Promise
Pride
Love Deluxe
Lovers Rock
Soldier Of Love

Sade no one-hit wonder
Their career legendary
And making the evening magical
Their music of soul, jazz and blues -
With a touch of pop -
Music I love and always will

Sade also having made brilliant music videos
Quality rather than quantity
And Sade will live forever in my heart.

1990: Manic Street Preachers

A world famous Welsh band
Formed in Blackwood Wales in 1986
Practising their guitars
And lyric writing
At their homes in Wales
After launching themselves
They to be taken seriously straight away
With those legendary guitars they play
And expertly play
James Dean Bradfield an expert
With putting lyrics to musical notes

And their albums keep coming:
Generation Terrorists
Gold Against The Soul
The Holy Bible
Everything Must Go
This Is My Truth Tell Me Yours

They are a hit factory
And their stage performances stellar
Manic Street Preachers
Going on and on: staying strong
Especially with their alternative rock sound
And political outlook
For this band does not do it by the book:
They do it with grace and originality.

2000: Girls Aloud

Girls Aloud created in 2002
ITV talent show "Popstars: The Rivals"
Five young women chosen
To be spectacular musical artists
With utterly brilliant music
And vibrant stage performances
Wearing the coolest rainbow outfits
And show stopping high heels
Albums to all be dance and pop
Appealing to many teenagers
And young people in general

Going on for many years
Girls Aloud have fun, exciting music:
Music that I love and find original
For Girls Aloud makes people
Get up with their friends and dance
And sing along with a hairbrush
Imagining themselves onstage
Singing "Sound Of The Underground"
Girls Aloud creating a new sound
The first Girls Aloud album recorded
The second album being
"What Will The Neighbours Say? "
Another fun and genius album
Chemistry one of my favourites
Girls Aloud to experiment
With electropop, dance-pop and dance-rock
Members being Cheryl, Nadine Coyle, Sarah Harding,
Nicola Roberts and Kimberley Walsh
I just cannot tire of this band
Although sadly Sarah Harding
Having cancer and passing away
She shall be remembered always
For being an important part of a band
That Guinness World Records listed them as
The 'Most Successful Reality TV Group' in the 2007 edition
And being nominated for five Brit Awards
Winning in 2009 for Best Single "The Promise".

2010: Jennifer Lopez

Jennifer Lopez a pop culture icon
Described as a triple threat entertainer:
Dancer, actress and singer
Having a film career
Grossing over 3.1 billion
And global record sales of 80 million
Jennifer Lopez is not a woman you can ignore
An utterly fabulous actress:
And an even better stage performer
A woman close to iron woman
Having been photographed
Millions of times
And having been interviewed
Millions of times
Jennifer Lopez worthy of her income
And will cheekbones so sharp
You could sharpen knives on them
Her music videos my favourite on YouTube
And with films like "Maid In Manhattan"

Her film career entertains the entire world
Her facets as an actor vast
No two characters ever the same
And with her earnings
She does wear the most beautiful dresses
And perfect high heels
That show off her long legs
For Jennifer Lopez believes in herself
And will never surrender or beg:
No matter what you try to do.

2020: Legends Ongoing

Musical legends go on and on
Their nostalgic memories
That are part of daily life
Being a true romantic
I truly feel music is part of my soul
From 1950 to beyond 2020
New music is out there all the time
Along with the oldies
But all music is relevant
All music is for everyone:
From the young to the old
From classical to rock
And we know we can't stop the clock
But we hold our memories
Like gold that makes us rich
Living our busy and important lives
Going to music concerts and the theatre
Just having fun and being with friends
Or even remembering that fantastic party
Where we danced to Girls Aloud
Or remembered our parents listening to Patsy Cline
In the lounge of an evening time
Where we looked back at our first love with Sade
Where we did live a diamond life
Just loving spreading our wings
And realizing if the stars can do it
Why can't we? We make our memories every day
And must know we are as great as the music we play.

Xaviere: Robot By Female Design

The robot made in Earth Year 3000,
Named the original name Xaviere,

A robot by female design,
By those engineers and scientists,
With their contracts to sign.

A robot pretty,
As she is functional,
Xaviere the modern name,
Her tasks to be decided,
Xaviere able to talk,
And talk quickly,
And she also does more than walk:
A robot able to carry out human tasks,
For Xaviere never becomes sickly,
Never gets tired, never gets bored,

Tasks always done,
Tasks never ignored,
And her eyes see the sun,
Even though a robot;
For her programming,
Works 24/7
Making the work place,
Easier to work in,
Work a lighter load,
And objects Xaviere does load,
For fewer work accidents,
And stress to unload,
For human workers,
And she works the hours,
From seven to eleven,
Even cracking secret codes,
When needed.

Xaviere a beautiful robot,
With sapphire eyes,
A roman nose,
And a perfect smile,
For she is made by female design,
The contract they did sign,
Xaviere worth millions,
The second of her kind,
After Sophia the robot,
Who knows the English language,
And is never able to be unkind,
And has eyes that are never blind,

For these robots are beautiful,
Unique, aesthetically pleasing,
With their appearance,
And highly intelligent machines,

That walk and talk,
Never with human emotions,
Like fear, rage, jealousy,
Hate and any other emotion,
But she does not feel love,
Whereas most humans do,
And Xaviere asks about this,
And asks how it feels to kiss,
But a robot does not know,
And will never know,
How love goes,
Although beautiful robots,
By female design.

Xaviere programming,
To be highly advanced,
No function left to chance,
Whether intellectual or physical,
For she is able to lift,
And carry heavy objects,
She is able to write words,
And solve complicated,
Mathematical equations,
She has that ability,
And her English stellar,
Her robot brain records words,
And can also record music,
That is being played on a stereo,

Xaviere built with care and love,
Even though she does not feel love,
Or other human emotions,
But this makes her fearless,
Able to do dangerous work,
And her programming,
Means she has the upper hand,
In the place of work,
Knowledge she does understand,
Her invention in demand,
Robots essential in industry,
And robots who carry the weight,
Without knowing their responsibility,
Nothing to hurt human hands.

An Old Episode Of Star Trek

Watching an old episode of Star Trek
I can only imagine being in space

Even though I have always
Flown on advanced airplanes
Man having once landed on the moon

I don't fear being in the sky
I don't fear being up that high
Thousands of feet up in the air
Sitting on that airplane seat
In comfort and with no care

Watching an old episode of Star Trek
I can only imagine being on the Space Station
Orbiting earth at hundreds of miles per hour
Through the change of day to night
Capturing images of earth in orbit

I don't fear travelling through outer space
I don't fear being up high
Beyond earth's atmosphere
Like a satellite travelling
Through the solar system and beyond

Watching that old episode of Star Trek
I see computers and touch screens
I see mobile talking devices
What we know now as smart phones
Talking across vast distances

Watching that old episode of Star Trek
I see a vision of the future
I see modern and amazing computers
I see NASA searching the Milky Way
I see NASA send satellites into deep space

The human race has reached
The incredible 21st century
We have technology beyond
What we thought we'd need
We have knowledge of science

We have a better understanding:
We know our physics
We know our chemistry
We know our biology
We know our mathematics

Time doesn't stop, the never ending clock
Time moves on constantly like the
Revolving of this beautiful earth

A blue and green fast spinning ball
That forever leaves us to think and recall.

Running Away In A Waitrose Trolley

I am sitting in a Waitrose trolley,
As my friends run me along,
For it is eleven at night,
And my parents and I,
Have been fighting,
Which I hate, but we have,
So many disagreements,
As they don't approve of my boyfriend,
Or my wild, outgoing friends.

I should be a good little girl,
And sit in front of the computer,
And do my coursework,
But I have a rebel heart,
I go out every night,
Although I am not a tart,
I just follow my heart,
And love my boyfriend so much.
My friends keep me sane,
I do know the teenage years,
Are hard, but they are great, too,
And teenagers don't always feel blue,
We all have heart and soul,
Once that school bell goes.

And I wear clothes,
That my parents don't approve of,
Short skirts and heels,
For I love those fashion magazines,
I have started to read Cosmo,
All my friends' older sisters do.
My bedroom walls,
Are covered in boyband posters,
And my floor is a work in progress,
But it is my room and my parents,
Are not welcome;
Even when I'm supposed to wash up.

So here I am tonight,
Running away in a Waitrose trolley,
My friends racing me along,
And school used to go slowly,
But I graduate soon,

And I shall never forget my friends,
These days, this young life,
My heart racing with happiness,
Moving with an escaping,
Waitrose trolley.

Should You Eat Crisps In Your Sandwich?

Should you eat crisps in your sandwich?
If you do
Then what flavour?
You could try tasty chicken
British bacon
Prawn cocktail
Salt and vinegar
Barbecue beef
Cheddar cheese
Cheese and onion
Or ready salted
Or even pickled onion,

There are many options
To your lunchtime sandwich
You could butter your bread
You could mayonnaise your bread
You could fill your bread
With slices of ham and cheese
Your bountiful brown bread
No matter what people you knew
In the past carelessly said

You could even use ketchup
Or that old marmite
And it is either
Love or hate
Some to marmite
That simply never relate
Marmite to them being
A factor of hate

And children
Throughout school
Put crisps in their predictable sandwiches
A trend throughout generations
A trend every adult remembers
Their childhood in the playground
Most memories happy

For parents usually

Teach values and skills
In every walk of life
So on a fun sunny day
Crisps are put in my work sandwich

Nostalgia colouring my adult world
Being carefree and happy
With the old tradition
Of being young and fun
And putting crisps in a lunchtime sandwich.

Forgetting The Perfect House

The newly married couple
Buy the perfect house:
It is in a prime location
It is a four bedroom house
And isn't in a flood area

The neighbours are pleasant
And talk in a friendly tone
The neighbours are welcoming
And nicely enquire
About the married couple

The married couple previously
Lived in a two-bedroom apartment:
An apartment that was too small
Especially with the husband
Being rather tall

Even though the apartment was cosy
It didn't suit their needs
It was cramped and sometimes dusty
Always needed to be aired out
And mould continually removed

So the married couple
Purchased a suburban house
With a busy highstreet nearby
With shops and other amenities
Including a public library and a cosy cafe

At first the new house was spotless
But then real life got in the way
The married couple had to go to work
They had so many bills to pay:
Bills that arrived like clockwork

So the blue carpet wasn't perfectly clean
The bins were not always taken out
But the washing up was done regularly
The laundry washed once a week
Yet still the house became undone

So the married couple hired a cleaner:
Their jobs meant they could afford one
And soon the house became shipshape
They had a clear floor again
And a clear sink every day

They soon realised
They had to forget the perfect house
Their apartment had been easier to clean
But now they live in a home
Where they keep heart and soul.

How To Make A Perfect Cup Of Tea

First start with a boiling kettle
Don't let yourself get distracted
Don't let anyone meddle
For you shall be master
Of the sophisticated kettle

Put the teabags into the cup:
Choose a stylish and colourful cup
With various designs from
Modern art to fun cartoons
To even famous mottos sung in songs

Pour the near boiling water
Into the cups of your choice
Making sure your teabags
Are Tetley Tea, PG Tips
Or even the defined Earl Grey

Consider different tea flavours
From fruit teas: to strawberry and raspberry
To herbal teas, such as peppermint tea
Just explore a local tea shop
And think about your tea options

Leave the chosen teabag
To brew for a good three minutes
Then thoroughly stir and pour

Add a dash of milk and some sugar
If you so desire

Your friends and family
Will certainly worship you
For making perfect tea
And your lunch breaks at work
Will never be boring with PG Tips

Because tea is worldwide
Its traditions and social events
Evolve around that cup of tea
People sitting and talking with cake
Together in each other's company

This includes PG Tips
With breakfast
Whether soggy breakfast cereal
Or a well cooked breakfast
Tea always drunk at the start of the day

Tea is served at lunchtime:
With any hot lunch
Enough food to settle the stomach
And stop those hunger pains
That strike when without enough food

Traditional tea to also be made
Of a relaxing evening time
Family sitting around the table
And knowing it'll be bedtime soon
Tea the next day they do correctly assume

So don't let your tea go cold:
Drink it all up and enjoy its lovely taste
Don't let all that effort go to waste
Because tea is an important tradition
And the way people will always bond.

Spider, spider

Spider, spider, on the wall,
Spider, spider, don't you fall.
Spider, spider, the most frightening of them all,
Spider, spider, with your long black legs on the wall.
Spider, spider, spin your web,
Spider, spider, may my fear ebb.

Dancing Spider

Walk on those elegant legs,
My dancing spider,
Dance on that web,
My dancing spider,
Spin your web like an intricate puzzle,
My dancing spider,
As you move and weave,
And those flies deceive,
My dancing spider.
For you are truly magical,
With your grace,
Such a natural with your gifts,
That you weave, play and dance,
Like the beautiful creature you are.

The African Terrain: Journey Of A Tarantula

The sun shines down hot
Onto the barren African terrain
A tarantula wandering
From his original home

But now he desires
A happy new home
Underneath the hot African sun
The tarantula searching
Crawling day after day
Night after night

People along the road
Respectfully letting him
Pass by: his spider body
Protecting him from the intense heat
That beats down upon him

And he feeds on the bugs
Along his never ending journey
Food in abundance
Food there to keep him alive

And after so many turns
Of sun-to-sun
The tarantula hasn't
Given up searching

And - finally - after all this effort
A human gently picks him up
Into his dark brown palm
And brown eyes treasure
The miracle of a beautiful spider
A spider with a soul

So in a box, this tarantula
Is taken to a new home
And into a fast car
Along the barren African terrain
Where he doesn't
Have to search anymore

Because an African man
Knows he was the goal
All along, treasuring
This independent tarantula that
Has walked over a 1000 miles
Just to find him
And bring him back home:
A forever home.

A Boy Playing With A Spider

A little boy spots a spider in the garden shed
Whereas most little boys want the spider dead
This little boy wants the spider alive
And wants to watch the innocent spider
Weave and deceive that complex web

A little boy wonders about the spider's web
Wonders what and how the spider eats
And how the small spider survives
In the dark and cold garden shed
A spider refusing to become dead

A little boy puts the small garden spider
On his young carpenters hands
Wishing to know how the spider works
How to read the spider's movements
And the spider's nature understand

A little boy playing with a spider
Not afraid of the small garden spider
A spider with a soul deep nature
No one able to stop a spider

Spinning its never ending sticky web

A little boy playing with a spider
Looking at its colours:
Colours of dark blue and white
An unusual spider that's for sure
Not all spiders' discovered plain black

A little boy growing up to love spiders
A little boy playing with a mysterious garden spider
A little boy reading on Wikipedia about spiders
A little boy teaching others to love garden spiders
A little boy to value mother nature with all its vibrancy.

The Spider Behind The Television

There is a spider behind the TV,
He is a big boy,
And scares even me,
But he is also a friend,
Crawling on my hand,
And keeping me company,
When I'm alone,
In the living room,
For he loves walking across the room,
And he has built a big web,
Ready to catch food,
For bugs to him,
Are like a juicy steak to us,
And he stays happily,
Behind the television,
Coming out sometimes,
Just to say hello,
For he is my spider behind the television,
Where he is left to his own devices,
And shall live a long life,
Being the friendly spider he is.

My spider has amazing senses:
He can jump and feel the air,
He knows when you're near,
He knows when you're far away,
But he always knows you're there,
He will crawl on your hand,
He will build his web,
A true work of art,
For my spider is mysterious,

He is unique and wonderful,
And too precious to be caged.

Danger Of The Stranger

Entering London
First friendly and funny friends
Then to unexpected enemies
All hatred consuming my soul
The danger of the stranger.

Childhood innocence
And safe childhood memories
Then school begins
From teenage to adult
Girls and boys
With deep insecurities
And having no voice
Where they obey without a choice
Being played like broken toys
Learning the danger of the stranger.

Growing into adulthood
To learn hatred and rage
Resentment and jealousy
Love gone, instead anger here
And much, much fear
The danger of the stranger.

A mad world, pain about,
Freedom a myth
Taught in childhood
Where once glorious colours
Now only black, white and grey
Like ebbing winter clouds
On that horrible school day
The cold world
A world made of stone
Leaving me to shiver to the bone
The danger of the stranger,

Like accepting tempting sweets
From that seemingly mature adult
But it is all a trick:
A trick of the light
Hard to defend oneself
And put up a self preserving fight
The adult to abuse,
Scold and emotions confuse

The mind lost in upset and dread
Sometimes wishing oneself dead
Where they live in a world
Where no one sees red
The danger of the stranger.

In my mind searing pain
Like a thousand knives
Piercing my bruised back
And leaving me to bleed
Ignored in my hour of need
To be branded a fool
Others hurting me to look cool
The danger of the stranger.

Seeing others suffer
Brings me down
To the lower levels of hell
Where Satan does his job well
Satan watching them bleed
And ignoring them
In their hour of need
Where they need permission
To make their dreams come true
Not knowing they
Had once been losers too
Having themselves fallen for
The danger of the stranger.

The Angel And The Devil

THE ANGEL

The angel walked a pretty path,
All the roses, lilies, violets,
And other beautiful flowers,
Blooming with perfume,
God's fragranced garden,
Above those white clouds,
Where airplanes can only pass,
Angels feathered wings,
Singing a melody,
Only an angel knows how to sing,

Her heart reaching out,
To all of God's world,
Until she fell,

Those clouds seeing her fall,
And saying hello to the devil,
An immortal, one of,
The mysteries of the universe.

His eyes enchanted with her,
Hungrily feeding,
On her pure soul,
Having been freed from hell,
But now knowing pain,
Once again,
Her wings not letting her off,
Out of the devil's heated world,
And place of anguish,
Wishing she had stayed,
In God's fragranced garden,
And not been a sinful angel,
Regret to wash down her face,
Saddened by all her crimes,
And now nightmares dressed up,
As pretty dreams to tempt the heart,
Women of the past, their dresses ripped,
Agony as they are torn at the seams.

THE DEVIL

The devil was told she had sinned,
Her feathered wings,
Falling from those white clouds,
An angel who did once sing,
But now terror waits,
Nightmare on Elm Street,
The devil singing her song,
No place in hell safe from fear.

But the devil also liked her,
And knew God loved her heart,
For in spite of her sins,
She was still an angel,
Soon no longer needing to burn,
Of a world that does always turn,
Some being roasted,
Like pigs in an oven,
The devil and his ox horns,
To trap those criminals,
And stop the murderers in their tracks,
Many chambers to choose from,

But now God's angel was here,

And God did tell the devil,
To play nice,
And play nice the devil did,
For she knew her sins,
And did repent,
The devil showing her errors,
That many make,
And lives she does not take,
For anger and pain does depart,
Love shining in her angelic heart,
Love a gift she now happily imparts,

For the problem with paradise,
Is that no one grows there,
Her soul knowing she has found,
Peace and release from her lesson.

But That's The Way The World Is, James

... If you don't look
Like you deserve that desk
You're not going to get that desk.

It seems life is cruel
But this saying
Is all too true:

'That's the way the world is, James:
If you don't look
Like you deserve that desk
You're not going to get that desk.'

Behind the mask
You should reveal yourself
Behind the mask
You could show them
Your true colours
Your emotions and intelligence
Creativity and motivation,

Life is never fair
You have to do as you dare
You have to show
Your skills and intelligence,
You have to be
Like everyone else
And work hard like you already do,

You deserve all the credit

You don't deserve to be in debit
Of your gains and achievements:
You shall gain it for yourself
And find yourself the hero,

You can know many things
If you're willing to learn,
You can reach for the stars
If you're eager to learn
And show passion
For your hard work,

So do feel pride
And never think yourself less
Because you are in charge
Of your own life
And yourself you shall impress
Along with everybody else,

So go out into the world
Face your working day
And know you are an achiever
Who has a right to be here
And a right to have fun,

So do show your true colours
For you are as beautiful as a rainbow
In the sunny blue sky.

Graffiti The Wall

Get your message across,
As she stabs the pavement with her stiletto heels,
Let her know about the ghetto,
The rough side of town,
She forgets about until walking the darkened streets,
For you fight for real issues, real equality,
And to walk the street with your head held high,
As your graffiti opens eyes,
And this is not pop art: this is the word,
These are real people who want to be heard.

Don't bury the hatchet; get up and fight,
Don't stop until you've got it right.
You've got class, guts and soul,
And no matter your background,
You know you're a fighter,
Going to the top,
So forget that art pop:

You've got a message to say; a stage to rock.

Graffiti tells no lies, its patterns of spray paint,
Telling a story of a world in living colour,
No matter the race: black, white, whatever,
Imagination and conviction holds no bounds,
Its graffiti artists interesting and diverse,
For they know the word on the street,
They keep 'em keen by being mean,
Their hair sometimes in ethnic style,
And rocking those skateboards and bikes,
Down to party-hard-road.

Junkies they protect, but pushers,
They don't pimp for,
Graffiti the background of their lives,
As the girls dress up in their war paint:
No colour, how shocking, banned,
And guys and girls rock those street fashions,
The city their roots, their soul,
And any place is fine to gather in,
For even though these are hard times,
This is also the time of their lives,
They being our sisters and brothers in the ghetto,
Dancing in the moonlight to rap from a boombox.

A Tin Of Biscuits

The tin of biscuits sits on the red checker tablecloth,
As family happily pluck out those biscuits,
Of short bread, cookies, bonbons,
Custard creams, jammie dodgers,
And other tasty biscuits,
For that tin of biscuits is a celebration,
Of Christmastime and a united family,

For family celebrating Christmas,
Is going all out in the food department,
And having laughter and such fun,
To admire the Christmas lights of the town,
Family standing together in the cold,
To watch everyone say their prayers aloud,

For the wonderfully decorated Christmas tree:
Both home and away, celebrate that special day,
When Christmas lights up the entire world,
Every family to sit in the lounge,
A tin of biscuits to celebrate the occasion,

Every Christmas tree to light up the towns,
And homes, of the people, glorious colours,
Of reds, greens, blues, purples, yellows,
Those decorations of gold stars and angels,
Children to look at in wonder,
For children love this time of year,
To celebrate Christmas with a smile and a cheer,

And even after Christmas dinner,
Of turkey and all the trimmings,
A tin of biscuits is shared,
And old classic movies to be watched,
"A White Christmas" never forgotten at this time of year,
Red wine and other alcohol everyone to drink instead of beer,
For later tonight, Father Christmas will be here,
To place excitement in the heart of children,
As they go to sleep reluctantly,
The morning not coming soon enough,
And rushing out of bed,
Parents sitting with a smile,
Knowing this precious time,
Worth the myth of Father Christmas,

And even those children in poverty,
Father Christmas brings joy,
For he saves the world,
Christmastime to heal the world,
People to join together,
And save the children and lonely elderly.

Christmas spirit all year long,
To unite the world and stay strong,
For at Christmastime we all belong.

Stupid? An Autistic Boy's Point Of View

What am I? Stupid?
No, I'm autistic.

I can think of no other jokes,
About my condition,
I do take things literally sometimes,
But I don't want to make you laugh,
And I don't want your judgements or scorn, either.
I am human, just like you,
Even though I get things wrong,
My reasoning a little off the mark,
But I am full of ideas,

And full of charm,
I love sharing my ideas with everybody,
And just love being creative!

I am a very playful 12 year old boy,
And films like 'Brave' and 'Harry potter' I enjoy,
I can imagine flying a broomstick,
And wonder why I can't in my backyard,
I get told it's only pretend,
But it looks so real, I get confused,
How does Harry stay in the air?
I have tried it, but my attempts always fail,
So my dad says he'll get me a helicopter!
And my mum says this doesn't make me a failure:
It makes me a hero,
I suppose she's right,
But I always imagine what she calls impossible,
To come true!
I mean, airplanes stay in the sky, right?
So why can't people?
I also wonder about many other things,
A curious mind, my mum calls it,
They also call me adventurous and brave.

My parents love me a great deal,
And always say there is no harm,
In having a vivid imagination!
I guess they're right, at the end of the day.
So when I start big school this September,
Maybe some of my dreams will come true:
No, I'd like all of them to come true,
Helicopter here I come!
I really am a young man of the times,
And am as bright as a button.

A Poor Girl In A Poor Town

Every day is the same in her home town,
She is just a poor girl in a poor town,
Always skipping school and barely skimming by,
It seems she has no ambitions,
But she knows the truth:
She will never be rich or famous,
No matter her qualifications,
She tries to see hope but just feels fear,
Because all roads lead nowhere,
Even with the radio station playing all her favourite songs,
But her life is no song,

Her mother ditched her a long time ago,
And her father is just her father,
There's nothing special about either of her parents,
And deep down, she knows it,
As she wakes up every Monday morning,
Knowing the same old week will play out,
For she is just a poor girl in a poor town,
Who will always face boundaries,
Of what she can and can't do,
She used to think she could make it through,
Try not to feel empty, lonely or blue,
But these are the times and she knows she is the loser,
And every day she looks at her life with misery,
For all hope has long since disappeared,
She thinks this as she sits in her postage sized flat,
The wind blowing heavily outside,
The car in the drive, undriven,
Because she has no place to go,
For all places are the same,
And will always be her prison.

Some People

There are some people who will lie to you,
There are some people who will tell you the truth,
There are some people who play games,
There are some people who laugh at your fears,
There are some people who trip you up,
There are some people who Chinese whisper,
There are some people who spread germs,
There are some people who are strange,
There are some people who are quirky with it,
There are some people who are lost,
There are some people who find you,
There are some people who are cowards,
There are some people who are heroes,
There are some people who strike you,
There are some people who hold back,
There are some people who will murder you,
There are some people who will steal from you,
There are some people who leave you stranded,
There are some people who spit and jeer.

It is a hard life,
But some people don't matter,
Remember: you're not one of them,
You can be different to some people,
You can be quirky and unique,

You can say thank you,
You can open doors,
And you can stay true to yourself,
Without tripping yourself up,
Or being used and abused,
Some people never hurting your feelings.

Ill Gotten Gains

Stealing is the name of the game,
Whether the old days of the pickpocket,
Or the modern day cybercrime,
Thievery in any century,
You could mention,

The public blinded by governments,
Throughout the history of the world,
The rich rolling in money,
As they feed their appetites,
On the taxes and rent of the poor,
So many of the lesser fortunate in debt,

And the rich spend money,
On holidays and cars,
Not caring about their corruption,
And their ill gotten gains,
The public always wishing for the same,

Those playboys with their six packs,
And the models with their skinniness,
As they roam down catwalks,
While rock stars smoke their cigarettes,
And ponder those ill gotten gains,
Although no celebrity to show their pain,
Emotions of guilt, for they have,
What others don't have:
Money and lots of it,
Feeling as if it was illegally gained,

For money was believed,
To be the root of all evil,
When priests punished children,
And warned the dangers of their souls,
If they allowed greed in,
But now we know, it is only true,
When money is stolen,
For this is the meaning of ill gotten gains,

Whether by a gun,
By violence, or by threats:
Thievery is all the same,
Money only the root of all evil,
When people are killed,
And left in dire straits,
To fend for themselves in poverty,
And in the pain of coldness,
Of a world without money.

My Life On The Dole

I live my life on the dole,
I have done for many years,
Even though I tried to find work,
I wandered from interview to interview,
Searching for something,
More than working behind a till,
More than packing boxes in a factory.

But times are hard,
And rent has to be paid,
Life goes on outside these four walls,
People are working nine to five,
And those hard workers venture out,
Trains, planes and buses full every,
Morning, noon and night,
While I sit in my apartment,
On the dole and wishing for more.

I am not the most confident,
But I am not a loser:
In spite of being poor,
And the government sees me,
As a useless statistic,
One of the lazy masses,
Claiming benefits,
In an already struggling economy,
Families struggling to pay rent,
And put food on the table.

The bedroom tax is a burden,
The competition for housing,
Overruling the news,
And we are branded scroungers,
Losers, no hopers;
But we are worth more than that,
I am getting on now,

But I worked in my youth,
For I was not always on benefits.

But my neighbours do,
Have to cope with drink and drugs,
Those buildings a breeding ground for crime,
But not all benefit claimers are criminals,
In fact, there are only a few on the dole who are so,
And we all have to survive somehow,
Taking tax payers money and causing anger,
Among the masses who work,
Who worked hard for their education,
Who paid their way in the world,

And I want to be one of them;
I want to be proud,
And have accomplishments,
And I will find a job;
So forgive my rough ways,
And have a cup of tea with me.

The Bird That Was Too Afraid To Fly

There once was a bird too afraid to fly
She didn't know how to relate to others
Yet she could never say goodbye
And every night she would cry and cry
For she was a bird too afraid to fly.

She would see others through a computer screen
Every night she would dream and dream
Every nightmare becoming obscene
Yet a nugget of gold
Began to take hold:

She could raise her wings
And soar through paradise
Where everyone knew her and loved her
And need never look twice
Her bird wings taking her through paradise.

And she learnt to believe in herself
She learnt how to gain valuable wealth
She took take her life and steer
At her party she would happily cheer
Knowing her bird wings brought her here:

Here to a never ending paradise

Where magnificent birds take full flight
Through the blue, blue sky
Knowing deeply how and why
They are able to fly,

For they are free
They cure all that is insane
And yet - somehow - make the mad free:
Free to paint colourful rainbows
And view birds soaring through paradise,

Where once fear held her down
Now she does no longer frown
For she is a bird of paradise
Who wears the heavenly kingdom crown
And know what she will always know:

That her wings are vast
That her wings take a chance
And rejoice with hope
And view life with scope
Having once been a bird too afraid to fly.

The Poisoned Cat

Caroline was a kind elderly woman
Who had a soft heart
And a great affection for cats
She would daily feed
Them irresistible Dreamies
Every night and every day

So popular were these cat treats
Cats would venture out
From their cosy homes
Through snow and rain
Across parks and fields
From the weather no shield

To sit inside Caroline's cosy kitchen
Lapping up delicious cream and milk
In clean cat feeding bowls
Enjoying the taste of Dreamies
Enjoying the company of Caroline
Enjoying being content and pampered cats

But what Caroline did not notice
Was the nasty next door neighbour

Looking through her stained net curtains
Feeling jealousy of Caroline's happiness
How she could dare live happily
Shown by Caroline's love of cats

The next day a cat found poisoned
From inside Caroline's once happy home
Her beautiful cats dead
Their empty feeding bowls
Now smelling of cat poison
A villain breaking Caroline's heart

But Caroline would find the cat killer
Caroline would save future cats
Her neighbourhood supporting her
Never ending months going by
And Caroline did still break down and cry
But she cleverly discovered the cat killer

Setting up a devious trap
Caroline caught the bitter old woman
Poisoning a deliberately placed feeding bowl
A feeding bowl no cat to eat or drink from
And the police came for Bitter Billie
Having her held down by police in her rage

With the cat killer behind bars
Caroline returned to entertaining cats
No cat ever poisoned again
Cats loving Caring Caroline
And coming from far and wide
To treasure a nice human on their side.

Average Joe And Jane

I am just your average Joe and Jane,
Where life is always the same,
And to the rich,
We forever play the same games,
Taunting yet clapping,
Money sometimes,
A web of deceit,
Your average Joe and Jane to cheat,
Whether in the casino,
Or other possibilities of life,
Such as the contract of a book,
Average Joe and Jane,
To take a second look,

And then turn into a master crook.

I am just your average Joe and Jane,
Where I am normal yet plain.
Although to wear makeup,
I always wear average clothes,
And always look the same,
With no stylish footwear,
And average hair care,
That visit to the hairdresser,
To just be an average hair cut,
Never looking like a model,
And when I do see a model,
I hear stories of acid,
Being thrown into their face,
To make them look ugly and a disgrace,
Jealousy to destroy a model's face.

I am just your average Joe and Jane,
Games of the mind,
Leaving fools and losers blind,
For money is quickly,
Parted from a fool,
And still a fool,
Until they graduate school,
Qualifications to be difficult,
Average Joe and Jane,
The same,
And barely skimming by,
Barely going for it and not to really try,
Those classmates doing much better,
And smiling when in their cars,
As average Joe and Jane,
Waits at the bus stop getting wetter.

I am just your average Joe and Jane,
Lack of money, people in dire straits,
And wishing to play the game,
Of criminality; of abuse and violence,
Where in the streets,
There is never silence,
As you always hear those sirens,
City life for average Joe and Jane,
And Joe and Jane to know the pain,
Of life without money,
Life of corruption,
Yet something keeping them alive,
As day passes day,
And night passes night,
To hear from the window,

Those gangster fights,
Knives used, children abused,
The evil world of average Joe and Jane,

But church offers redemption,
As I write these words,
For poor does not always equal evil,
Rich does not always equal corrupt,
For evil starts in the soul,
And where the soul goes,
No one knows,
But I know this:
I am your average Joe and Jane,
But I am beautiful on the inside,
Where this soul has nothing to hide,
And where all the colours of the rainbow,
Give me self respect and pride.

THE END:
But a beginning as your mind wanders
Words taking you on a journey
Your heart has always desired
And your life
As Average Joe and Jane
Is anything but ordinary
And you don't give up hope
Taking up opportunities
As they appear
Like the hot sun in the morning
And painting all the colours of the rainbow
Into your life
Like vibrant paint on a canvas.

Paula Glynn
Winter 2022

www.ingramcontent.com/pod-product-compliance
Lightning Source LLC
Chambersburg PA
CBHW081812220526
45468CB00006B/1816